I Can Count Numbers
And Color Too!

Venice Gray-Smalling

Copyright © 2016 Venice Gray-Smalling

All rights reserved.

ISBN:1539428958
ISBN-13:9781539428954

DEDICATION

I, dedicate this book to Shackera S. Smalling

I love you

CONTENTS

	Acknowledgments	i
1	Write your Childs Name on this Page	1
2	Number One	Pg #1
3	Number Two	Pg #2
4	Number Three	Pg #3
5	Number Four	Pg #4
6	Number Five	Pg #5
7	Number Six	Pg #6
8	Number Seven	Pg #7
79	Number Eight	Pg #8
10	Number Nine	Pg #9
11	Number Ten	Pg #10
12	Number Eleven	Pg #11
13	Number Twelve	Pg #12
14	Number Thirteen	Pg #13
15	Number Fourteen	Pg #14
16	Number Fifteen	Pg #15
17	Number Sixteen	Pg #16
18	Number Seventeen	Pg #17
19	Number Eighteen	Pg #18
20	Number Nineteen	Pg #19
21	Number Twenty	Pg #20
22	Write the Numbers Names	Pg# 21
23	Match The Number And Their Names	Pg #22

ACKNOWLEDGMENTS

I, give all glory and honor to God for blessing me with skills that he knew I would need some day.

My Uncle, Rohan Smith who has been a great motivator.

My, Mom who has always believed in me and kept me in her prayers.
Love always.

1

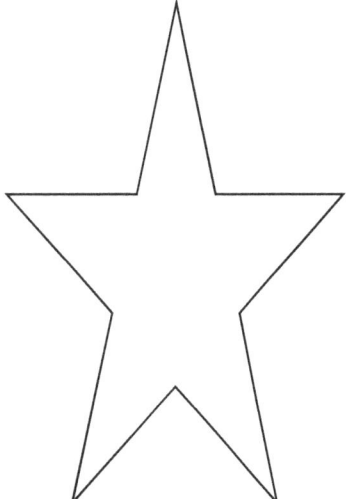

ONE

Color me, Yellow

2

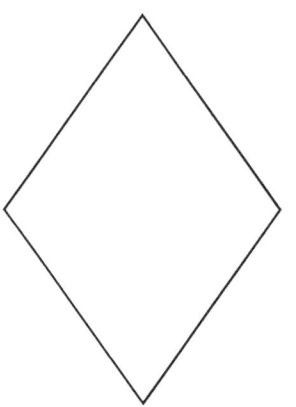

TWO

Color me, Blue

I Can Count Numbers

3

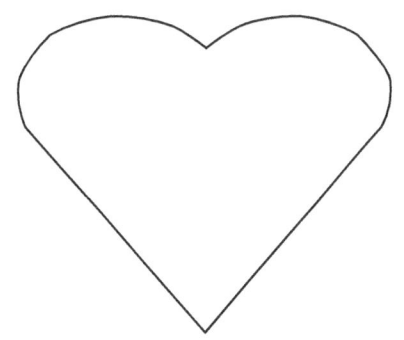

THREE

Color me, Red

4

FOUR

Color me, Green

I Can Count Numbers

5

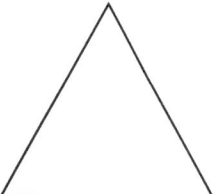

FIVE
Color me, Purple

6

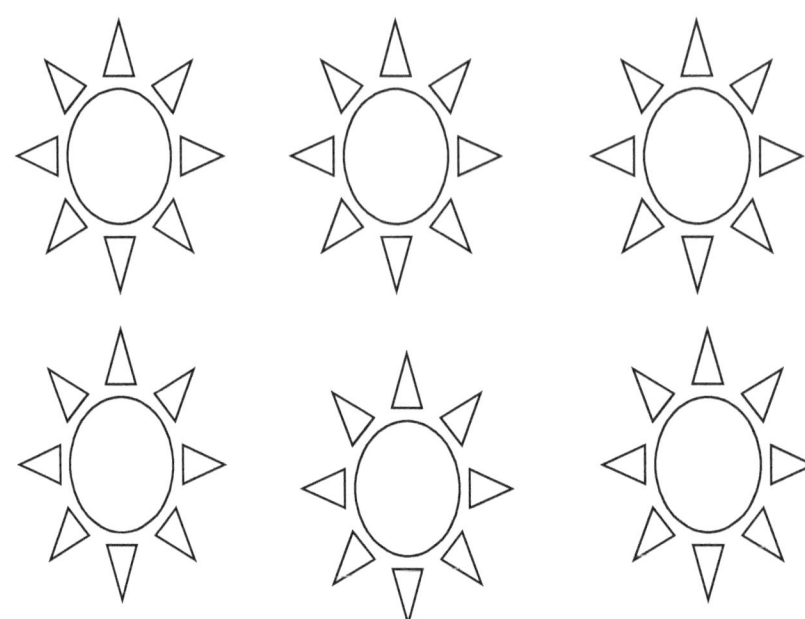

SIX

Color me, Orange

7

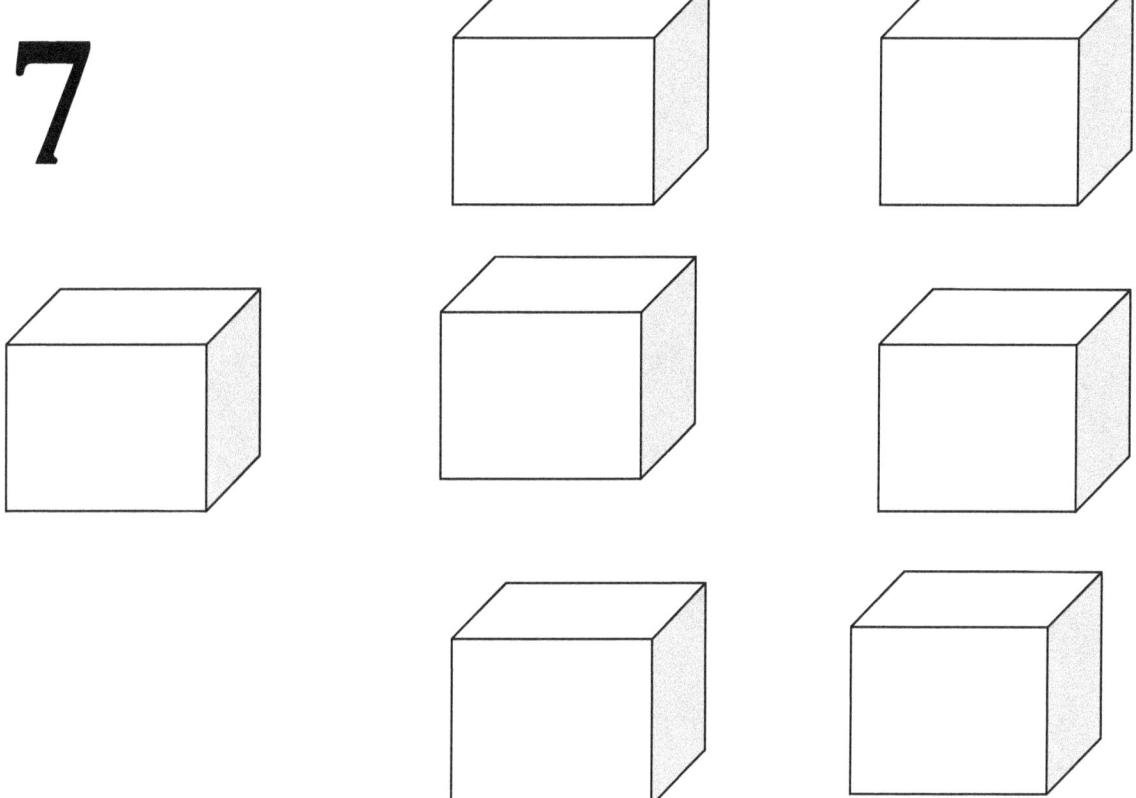

SEVEN

Color me, pink

8

EIGHT
Color me, black

I Can Count Numbers

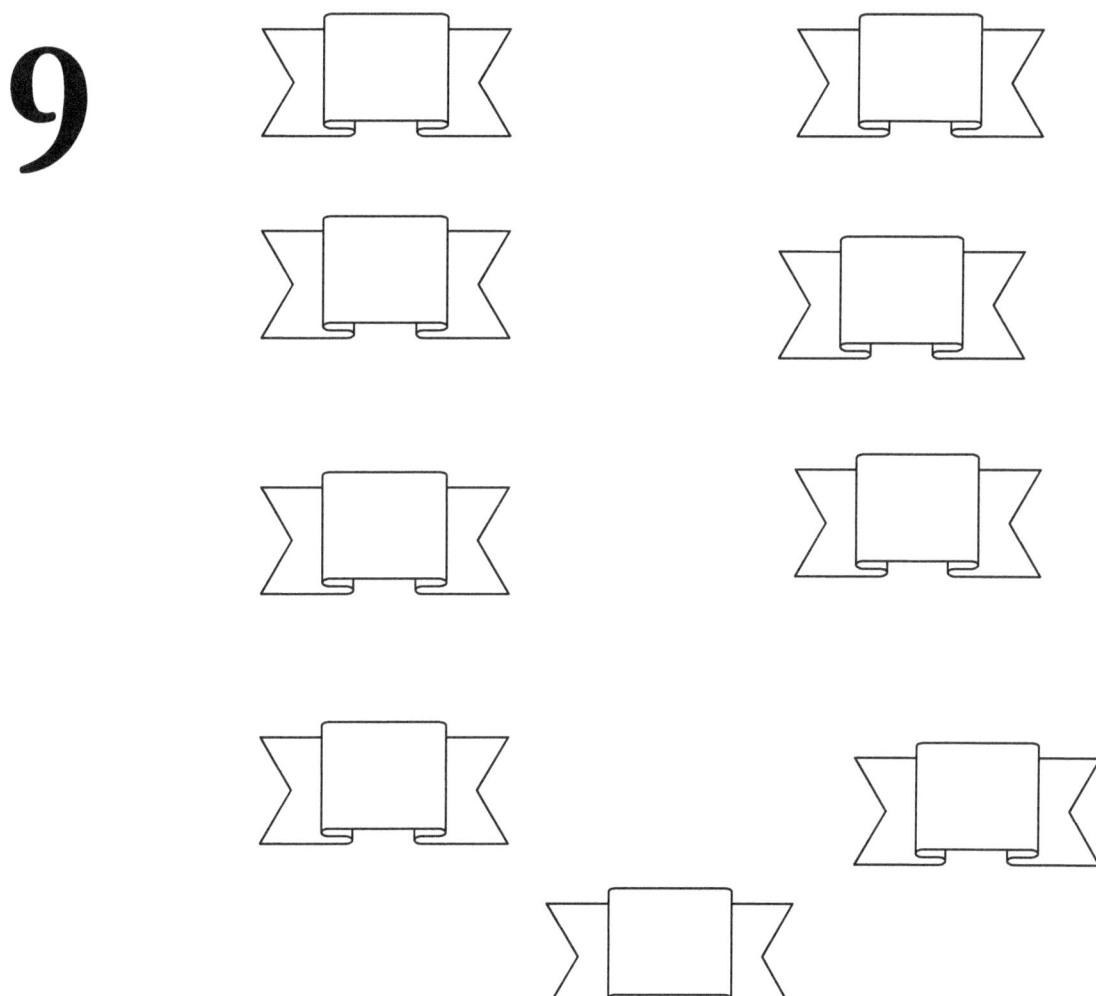

NINE
Color me, Grey

10

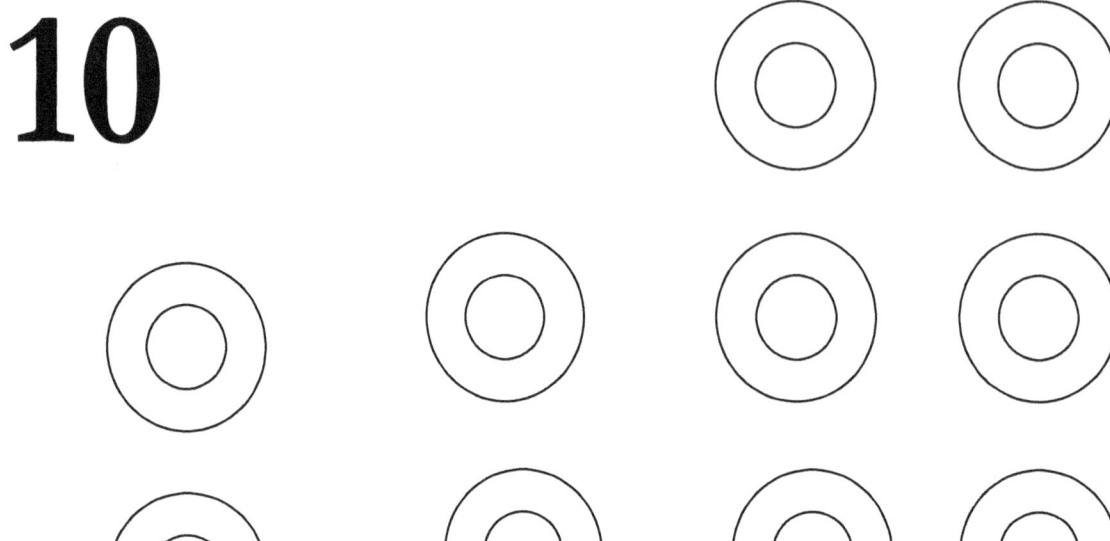

TEN
Color me, brown

I Can Count Numbers

11

ELEVEN

Color me, yellow

12

TWELVE

Color me, peach

I Can Count Numbers

13

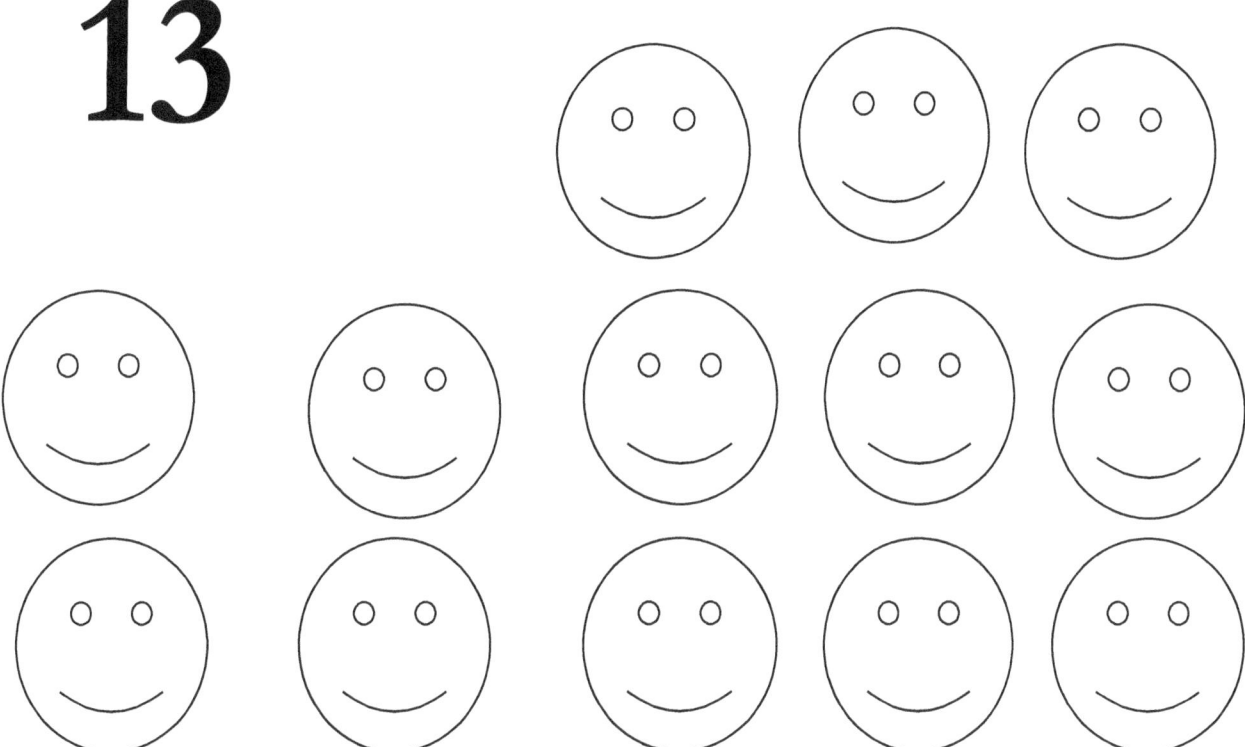

THIRTEEN

Color me, Gold

14

FOURTEEN

Color me, yellow green

I Can Count Numbers

15

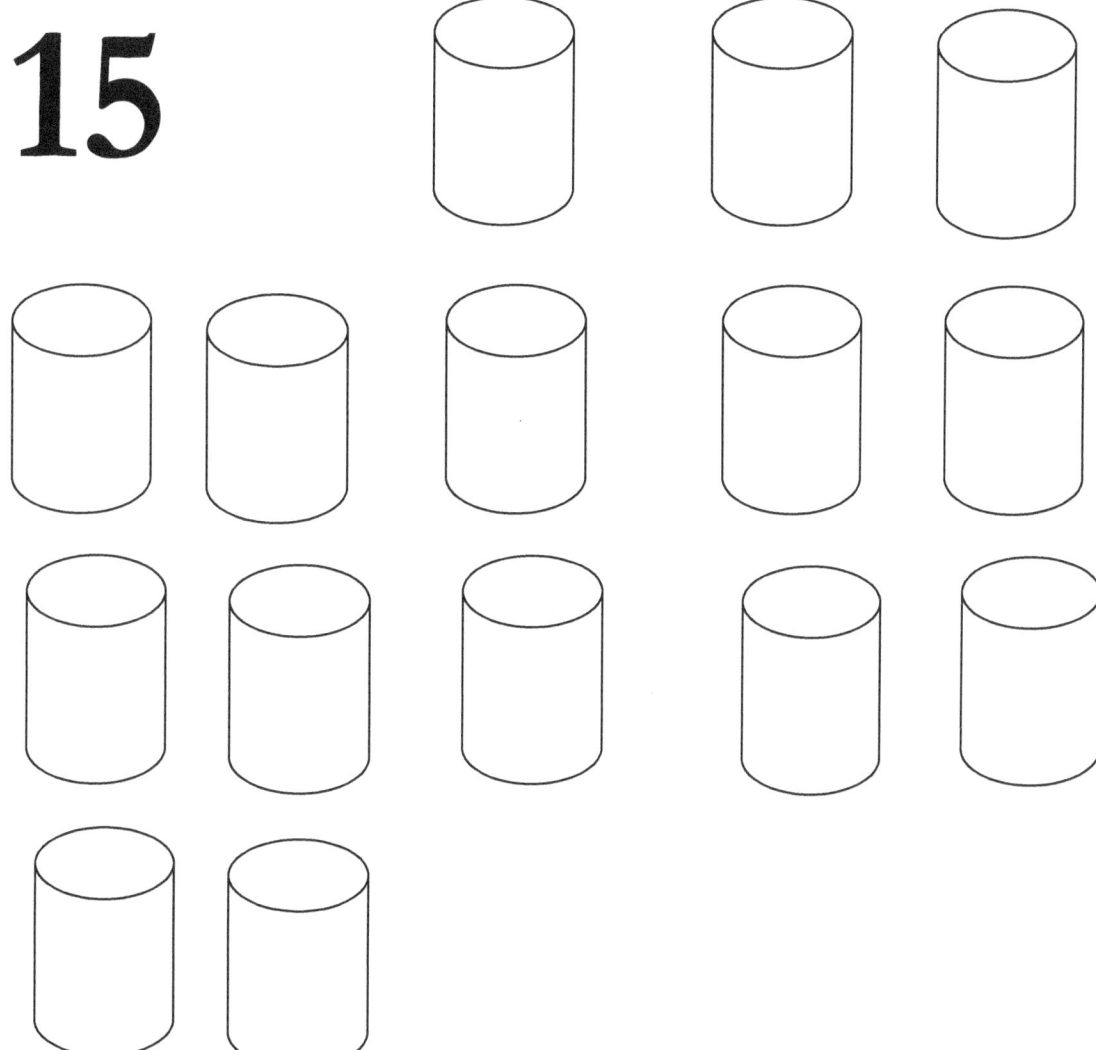

FIFTEEN

Color me, Sky Blue

16

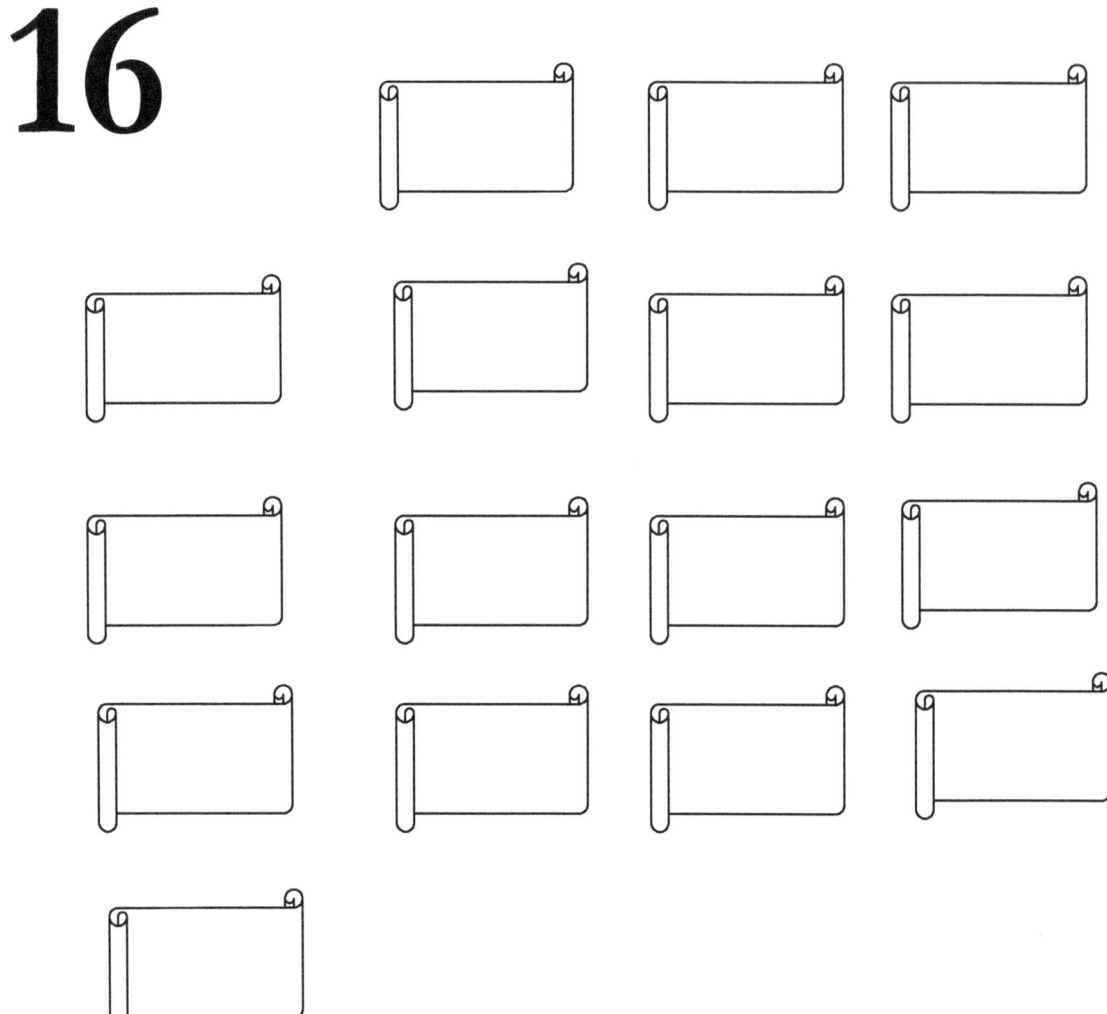

SIXTEEN

Color me, violet

17

SEVENTEEN

Color me, Orange

18

EIGHTEEN

Color me, Red, yellow, Green and Blue

I Can Count Numbers

19

NINETEEN

Color me, Pink

20

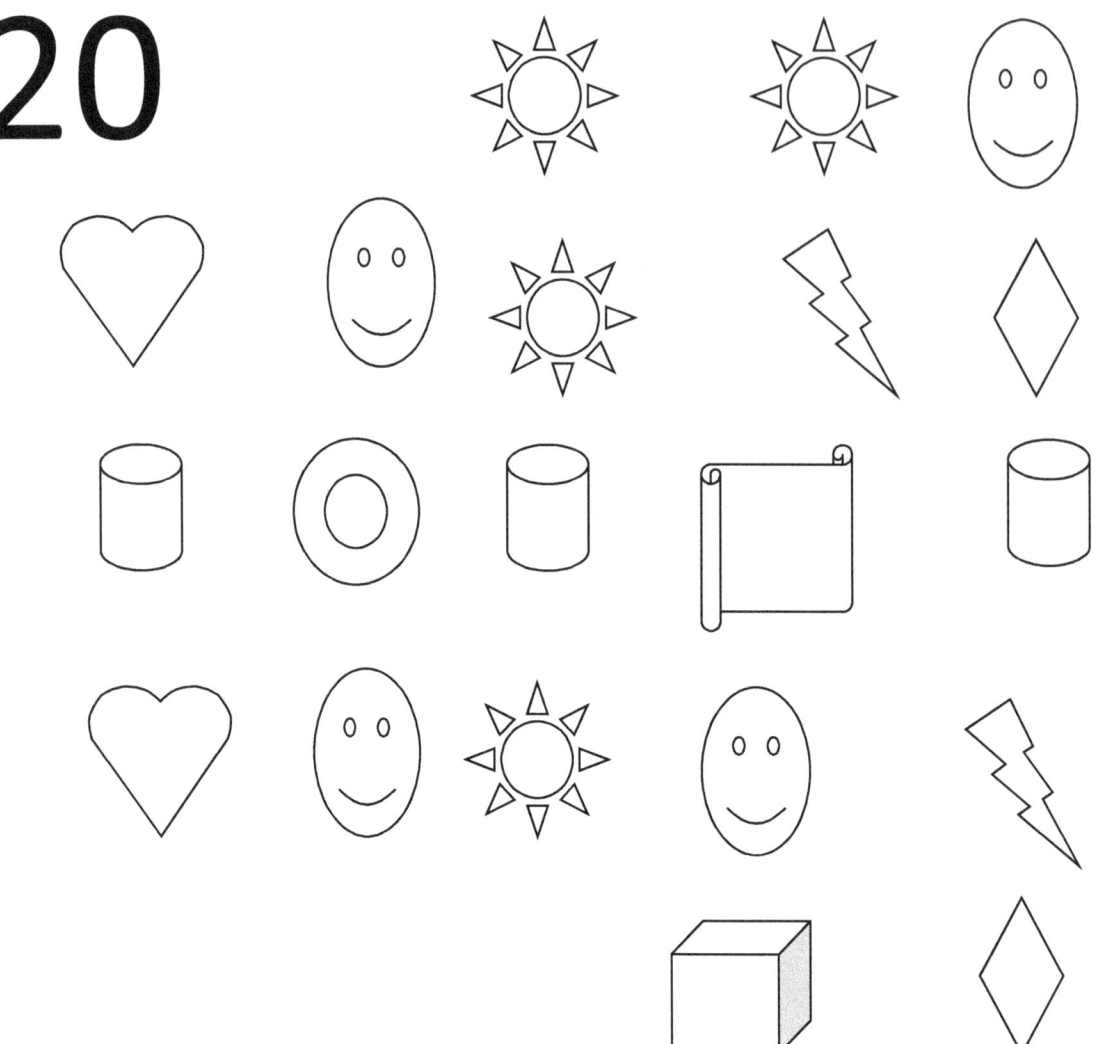

TWENTY

Color me, with all the colors.

I Can Count Numbers

Write The Number Names.

The First One Is Done For You.

1. _____One_____ 6. _____

2. _____ 7. _____

3. _____ 8. _____

4. _____ 9. _____

5. _____ 10. _____

11. _____ 12. _____

13. _____ 14. _____

15. _____ 16. _____

17. _____ 18. _____

19. _____ 20. _____

Match The Number And Their Names

The First One Is Done For You

1	Ten
4	Eight
6	Six
10	Nine
3	One
7	Four
2	Three
5	Five
8	Two
9	Seven

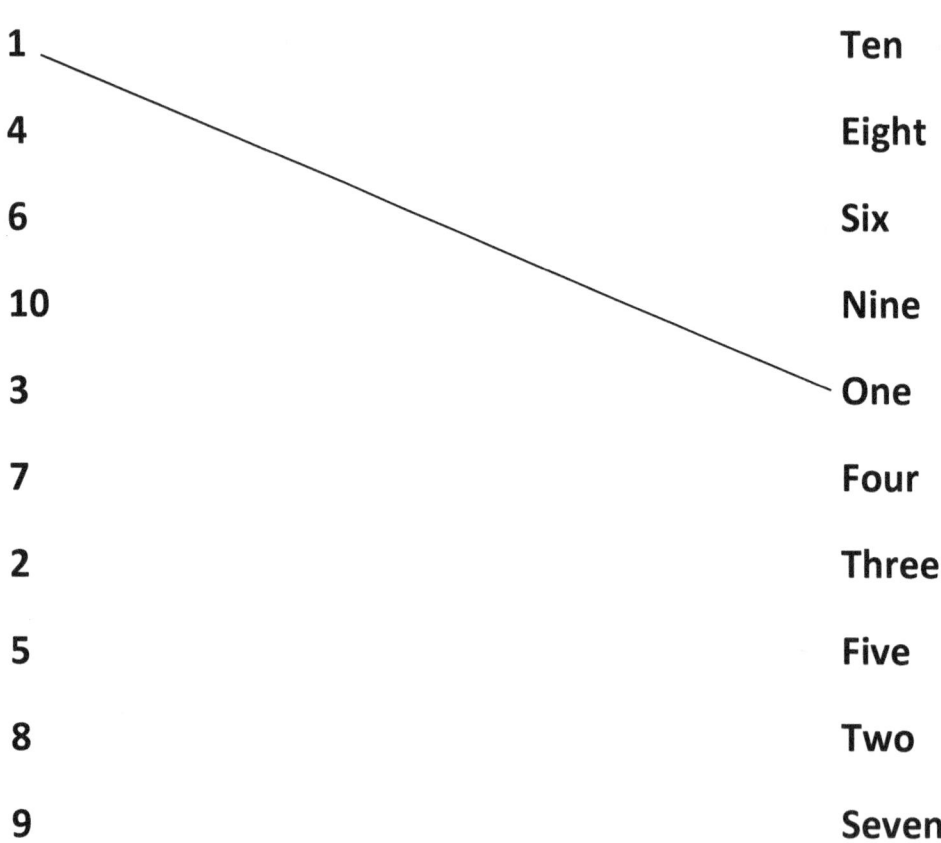

Instructions

1. Ask your child to count with you.

2. Ask your child to guess the objects.

3. Ask your child to memorize the number names.

4. Ask your child to memorize the color names.

5. Color the shapes and objects with your child.

Have fun!

www.ingramcontent.com/pod-product-compliance
Lightning Source LLC
Chambersburg PA
CBHW080529190526
45169CB00008B/3104